ALABASTER

Printed in Canada

Contact
hello@alabasterco.com
www.alabasterco.com

Alabaster Co. The Bible Beautiful.
Visual imagery & thoughtful design integrated within the Bible.
Cultivating conversation between art, beauty, & faith.

Founded in 2016.

NLT.

ARTIST INTRODUCTION

——

Esther is a curious book of the Bible. Throughout the entirety of its text, God goes unmentioned. This might seem strange at first—for something within the Biblical canon—but in this dramatic, plot-twisting, excitement-driven story, God is at work.

Historically, Esther was written to recount the significance of the Jewish festival, Purim. It commemorates the saving of the Jews from Haman, the book's antagonist, and his plot to destroy the Jewish people. Purim can be translated to "lots", a form of decision-making that appears to be made by chance (such as "casting lots" or "rolling dice").

The brilliance of Esther is its mysterious, unique intermingling of chance and divine providence. While its plot appears random, and chance-filled at first—it is an invitation to see it as a fateful encounter with God.

We explore this dramatic story with a color of mystery and divinity—Fateful Jade. Much of the book and Purim is structured around celebration; we explore this using imagery of banquets, foliage, and ribbon to tie-up key moments in Esther. We also explore accidental moments, subject matters unlikely to align together in natural circumstances.

Perhaps Esther is an invitation to all of humanity, to watch and to listen—with curiosity and attentiveness—for the implicit workings of God in serendipitous moments. It may not be explicit or how we would expect, but certainly God is there. Amen.

BOOK OF

ESTHER

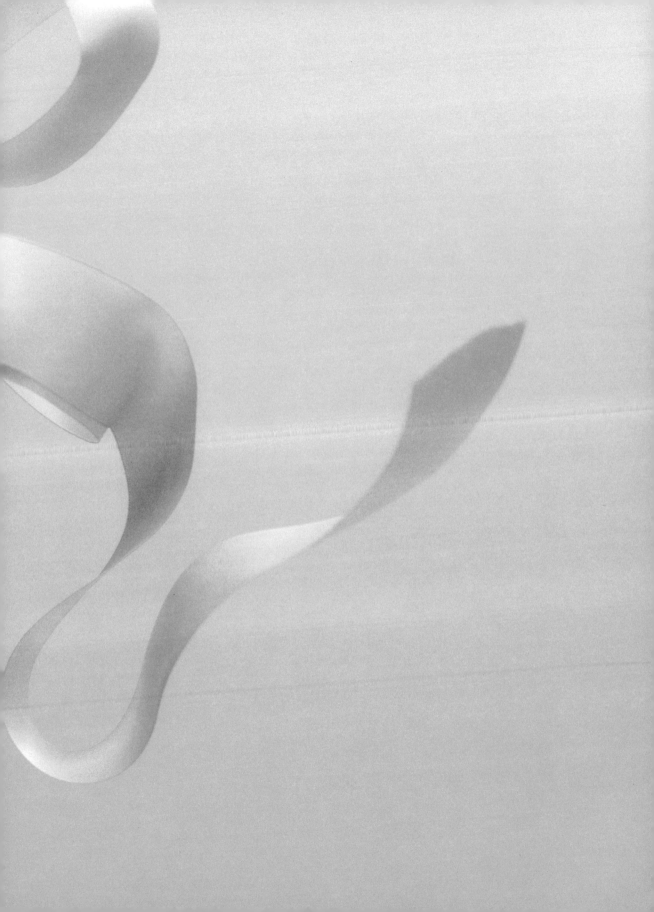

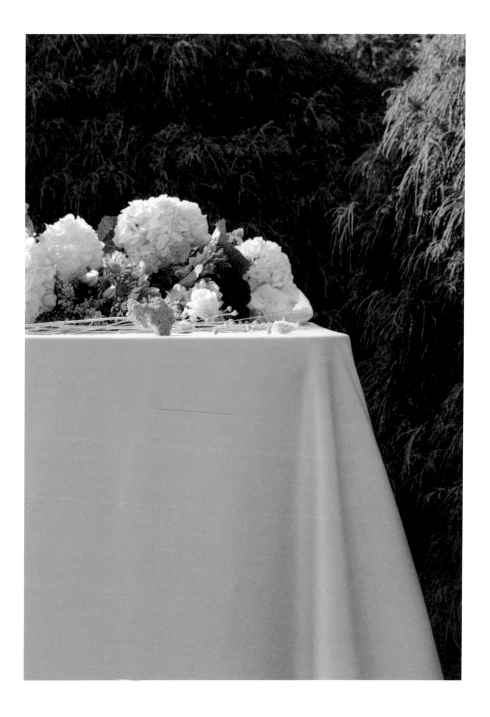

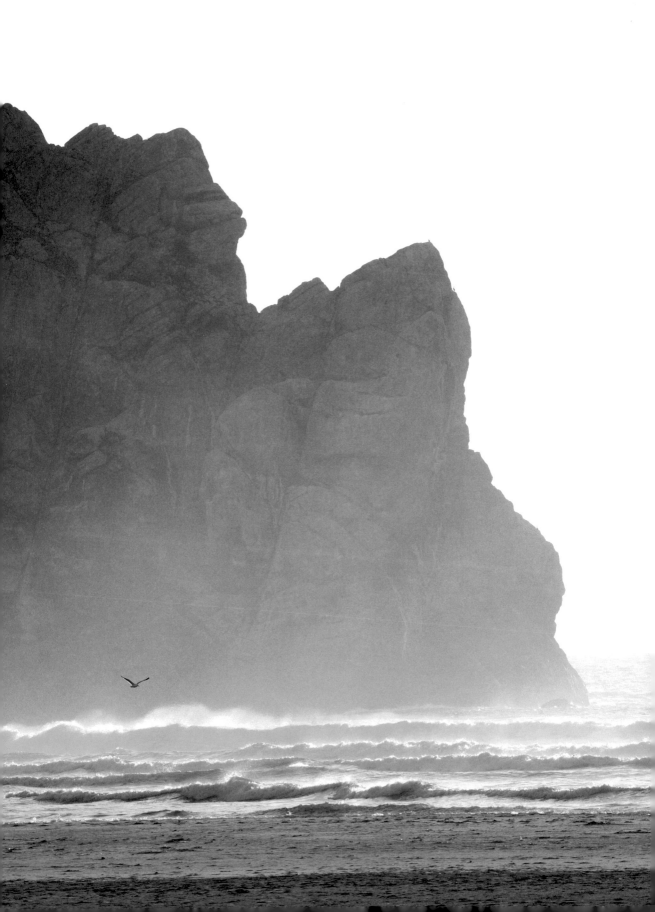

1

THE KING'S BANQUET

[1] These events happened in the days of King Xerxes, who reigned over 127 provinces stretching from India to Ethiopia. [2] At that time Xerxes ruled his empire from his royal throne at the fortress of Susa. [3] In the third year of his reign, he gave a banquet for all his nobles and officials. He invited all the military officers of Persia and Media as well as the princes and nobles of the provinces. [4] The celebration lasted 180 days—a tremendous display of the opulent wealth of his empire and the pomp and splendor of his majesty. [5] When it was all over, the king gave a banquet for all the people, from the greatest to the least, who were in the fortress of Susa. It lasted for seven days and was held in the courtyard of the palace garden. [6] The courtyard was beautifully decorated with white cotton curtains and blue hangings, which were fastened with white linen cords and purple ribbons to silver rings embedded in marble pillars. Gold and silver couches stood on a mosaic pavement of porphyry, marble, mother-of-pearl, and other costly stones. [7] Drinks were served in gold goblets of many designs, and there was an abundance of royal wine, reflecting the king's generosity. [8] By edict of the king, no limits were placed on the drinking, for the king had instructed all his palace officials to serve each man as much as he wanted. [9] At the same time, Queen Vashti gave a banquet for the women in the royal palace of King Xerxes.

QUEEN VASHTI DEPOSED

[10] On the seventh day of the feast, when King Xerxes was in high spirits because of the wine, he told the seven eunuchs who attended him—Mehuman, Biztha, Harbona, Bigtha, Abagtha, Zethar, and Carcas—[11] to bring Queen Vashti to him with the royal crown on her head. He wanted the nobles and all the other men to gaze on her beauty, for she was a very beautiful woman. [12] But when they conveyed the king's order to Queen Vashti, she refused to come. This made the king furious, and he burned with anger.

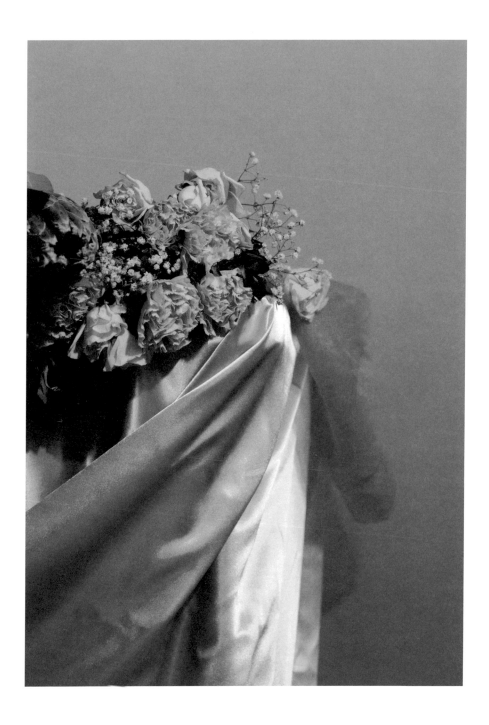

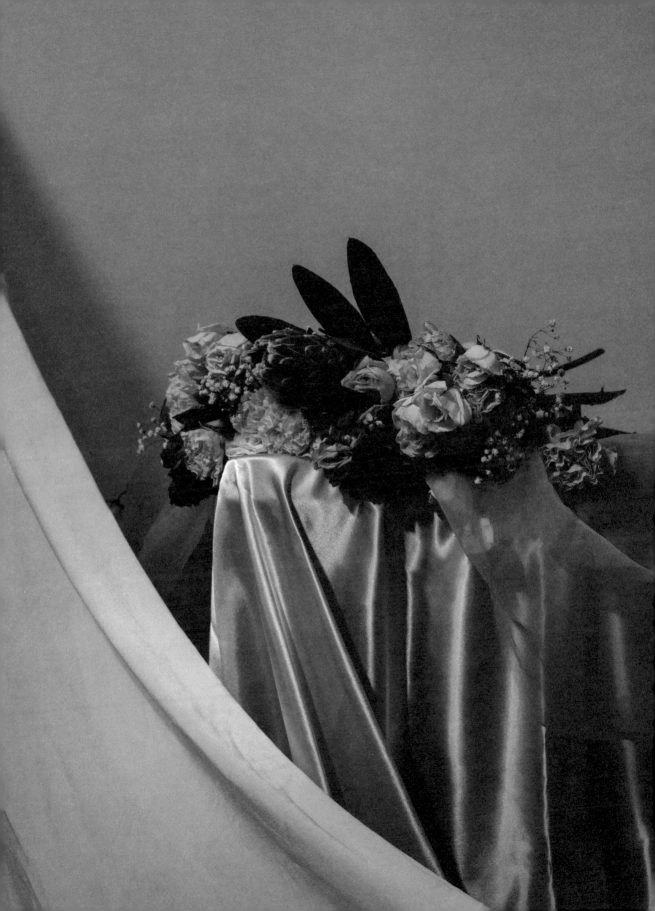

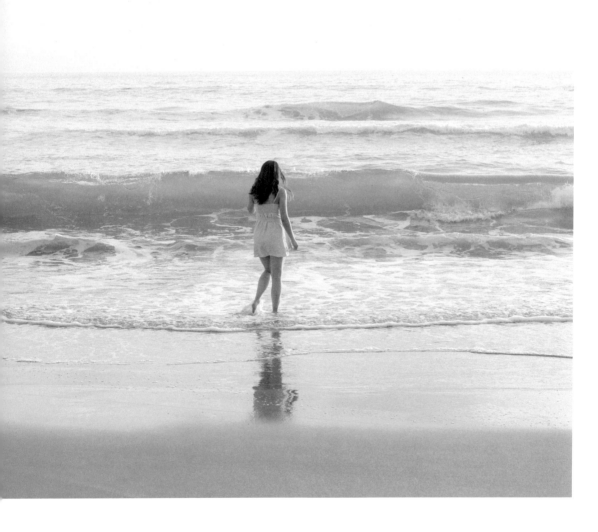

[13] He immediately consulted with his wise advisers, who knew all the Persian laws and customs, for he always asked their advice. [14] The names of these men were Carshena, Shethar, Admatha, Tarshish, Meres, Marsena, and Memucan—seven nobles of Persia and Media. They met with the king regularly and held the highest positions in the empire. [15] "What must be done to Queen Vashti?" the king demanded. "What penalty does the law provide for a queen who refuses to obey the king's orders, properly sent through his eunuchs?" [16] Memucan answered the king and his nobles, "Queen Vashti has wronged not only the king but also every noble and citizen throughout your empire. [17] Women everywhere will begin to despise their husbands when they learn that Queen Vashti has refused to appear before the king. [18] Before this day is out, the wives of all the king's nobles throughout Persia and Media will hear what the queen did and will start treating their husbands the same way. There will be no end to their contempt and anger. [19] So if it please the king, we suggest that you issue a written decree, a law of the Persians and Medes that cannot be revoked. It should order that Queen Vashti be forever banished from the presence of King Xerxes, and that the king should choose another queen more worthy than she. [20] When this decree is published throughout the king's vast empire, husbands everywhere, whatever their rank, will receive proper respect from their wives!" [21] The king and his nobles thought this made good sense, so he followed Memucan's counsel. [22] He sent letters to all parts of the empire, to each province in its own script and language, proclaiming that every man should be the ruler of his own home and should say whatever he pleases.

2

ESTHER BECOMES QUEEN

[1] But after Xerxes' anger had subsided, he began thinking about Vashti and what she had done and the decree he had made. [2] So his personal attendants suggested, "Let us search the empire to find beautiful young virgins for the king. [3] Let the king appoint agents in each province to bring these beautiful young women into the royal harem at the fortress of Susa. Hegai, the king's eunuch in charge of the harem, will see that they are all given beauty treatments. [4] After that, the young woman who most pleases the king will be made queen instead of Vashti." This advice was very appealing to the king, so he put the plan into effect.

⁵ At that time there was a Jewish man in the fortress of Susa whose name was Mordecai son of Jair. He was from the tribe of Benjamin and was a descendant of Kish and Shimei. ⁶ His family had been among those who, with King Jehoiachin of Judah, had been exiled from Jerusalem to Babylon by King Nebuchadnezzar. ⁷ This man had a very beautiful and lovely young cousin, Hadassah, who was also called Esther. When her father and mother died, Mordecai adopted her into his family and raised her as his own daughter.

[8] As a result of the king's decree, Esther, along with many other young women, was brought to the king's harem at the fortress of Susa and placed in Hegai's care. [9] Hegai was very impressed with Esther and treated her kindly. He quickly ordered a special menu for her and provided her with beauty treatments. He also assigned her seven maids specially chosen from the king's palace, and he moved her and her maids into the best place in the harem. [10] Esther had not told anyone of her nationality and family background, because Mordecai had directed her not to do so. [11] Every day Mordecai would take a walk near the courtyard of the harem to find out about Esther and what was happening to her. [12] Before each young woman was taken to the king's bed, she was given the prescribed twelve months of beauty treatments—six months with oil of myrrh, followed by six months with special perfumes and ointments. [13] When it was time for her to go to the king's palace, she was given her choice of whatever clothing or jewelry she wanted to take from the harem. [14] That evening she was taken to the king's private rooms, and the next morning she was brought to the second harem, where the king's wives lived. There she would be under the care of Shaashgaz, the king's eunuch in charge of the concubines. She would never go to the king again unless he had especially enjoyed her and requested her by name. [15] Esther was the daughter of Abihail, who was Mordecai's uncle.

(Mordecai had adopted his younger cousin Esther.)
When it was Esther's turn to go to the king, she
accepted the advice of Hegai, the eunuch in charge
of the harem. She asked for nothing except what he
suggested, and she was admired by everyone who saw
her. [16] Esther was taken to King Xerxes at the royal
palace in early winter of the seventh year of his reign.
[17] And the king loved Esther more than any of the
other young women. He was so delighted with her
that he set the royal crown on her head and declared
her queen instead of Vashti. [18] To celebrate the
occasion, he gave a great banquet in Esther's honor
for all his nobles and officials, declaring a public
holiday for the provinces and giving generous gifts to

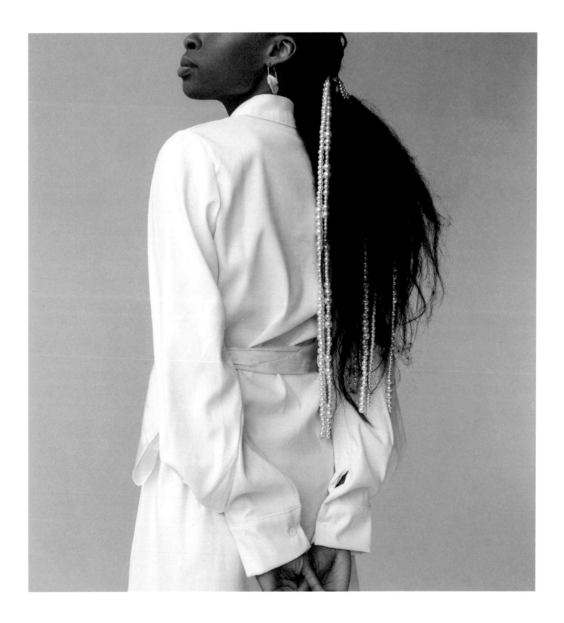

everyone. [19] Even after all the young women had been transferred to the second harem and Mordecai had become a palace official, [20] Esther continued to keep her family background and nationality a secret. She was still following Mordecai's directions, just as she did when she lived in his home.

MORDECAI'S LOYALTY TO THE KING

[21] One day as Mordecai was on duty at the king's gate, two of the king's eunuchs, Bigthana and Teresh—who were guards at the door of the king's private quarters—became angry at King Xerxes and plotted to assassinate him. [22] But Mordecai heard about the plot and gave the information to Queen Esther. She then told the king about it and gave Mordecai credit for the report. [23] When an investigation was made and Mordecai's story was found to be true, the two men were impaled on a sharpened pole. This was all recorded in *The Book of the History of King Xerxes' Reign.*

3

HAMAN'S PLOT AGAINST THE JEWS

[1] Some time later King Xerxes promoted Haman son of Hammedatha the Agagite over all the other nobles, making him the most powerful official in the empire. [2] All the king's officials would bow down before Haman to show him respect whenever he passed by, for so the king had commanded. But Mordecai refused to bow down or show him respect. [3] Then the palace officials at the king's gate asked Mordecai, "Why are you disobeying the king's command?" [4] They spoke to him day after day, but still he refused to comply with the order. So they spoke to Haman about this to see if he would tolerate Mordecai's conduct, since Mordecai had told them he was a Jew. [5] When Haman saw that Mordecai would not bow down or show him respect, he was filled with rage. [6] He had learned of Mordecai's nationality, so he decided it was not enough to lay hands on Mordecai alone. Instead, he looked for a way to destroy all the Jews throughout the entire

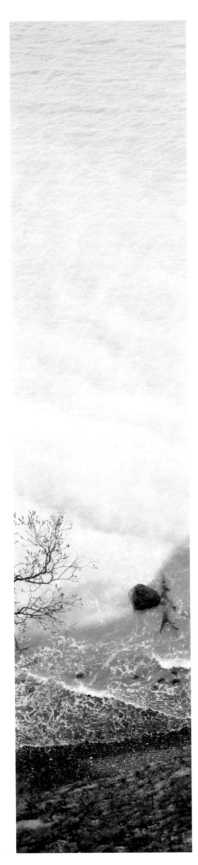

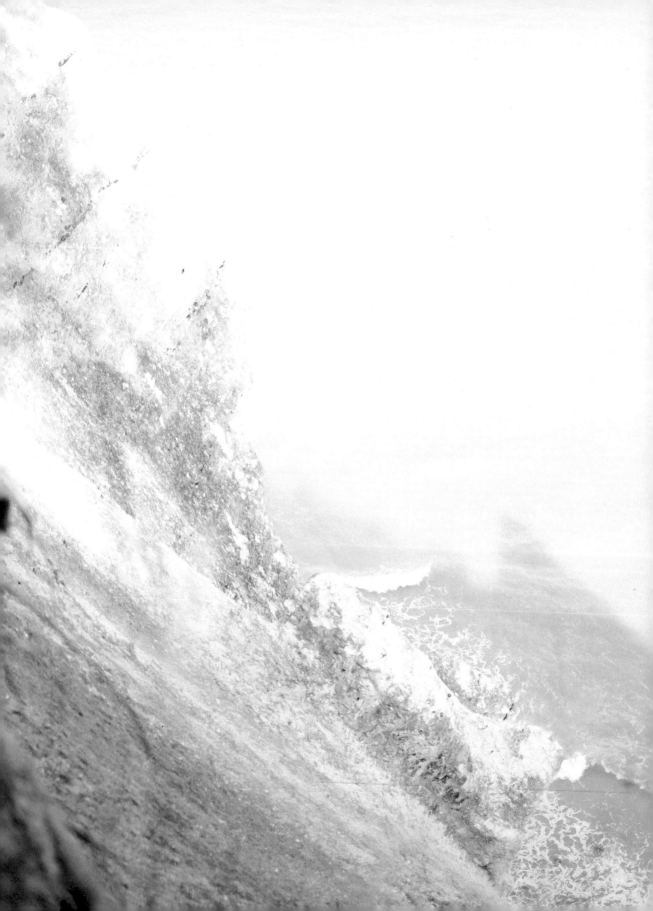

empire of Persia. So in the month of April, during the twelfth year of King Xerxes' reign, lots were cast in Haman's presence (the lots were called *purim*) to determine the best day and month to take action. And the day selected was March 7, nearly a year later.

[8] Then Haman approached King Xerxes and said, "There is a certain race of people scattered through all the provinces of your empire who keep themselves separate from everyone else. Their laws are different from those of any other people, and they refuse to obey the laws of the king. So it is not in the king's interest to let them live. [9] If it please the king, issue a decree that they be destroyed, and I will give 10,000 large sacks of silver to the government administrators to be deposited in the royal treasury." [10] The king agreed, confirming his decision by removing his signet ring from his finger and giving it to Haman son of Hammedatha the Agagite, the enemy of the Jews. [11] The king said, "The money and the people are both yours to do with as you see fit." [12] So on

April 17 the king's secretaries were summoned, and a decree was written exactly as Haman dictated. It was sent to the king's highest officers, the governors of the respective provinces, and the nobles of each province in their own scripts and languages. The decree was written in the name of King Xerxes and sealed with the king's signet ring. [13] Dispatches were sent by swift messengers into all the provinces of the empire, giving the order that all Jews—young and old, including women and children—must be killed, slaughtered, and annihilated on a single day. This was scheduled to happen on March 7 of the next year. The property of the Jews would be given to those who killed them. [14] A copy of this decree was to be issued as law in every province and proclaimed to all peoples, so that they would be ready to do their duty on the appointed day. [15] At the king's command, the decree went out by swift messengers, and it was also proclaimed in the fortress of Susa. Then the king and Haman sat down to drink, but the city of Susa fell into confusion.

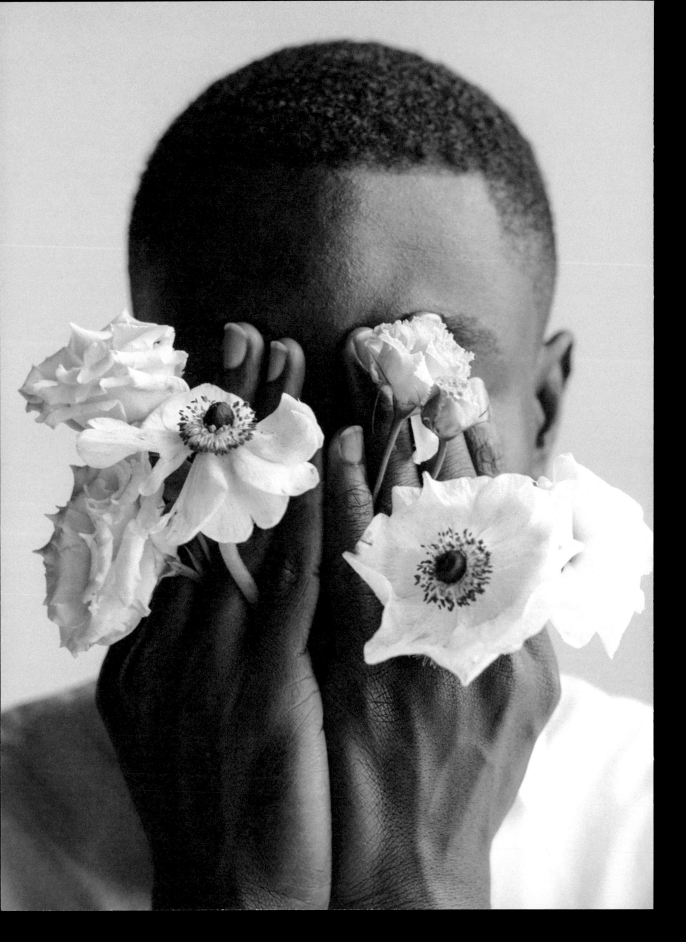

4

MORDECAI REQUESTS ESTHER'S HELP

[1] When Mordecai learned about all that had been done, he tore his clothes, put on burlap and ashes, and went out into the city, crying with a loud and bitter wail. [2] He went as far as the gate of the palace, for no one was allowed to enter the palace gate while wearing clothes of mourning. [3] And as news of the king's decree reached all the provinces, there was great mourning among the Jews. They fasted, wept, and wailed, and many people lay in burlap and ashes.

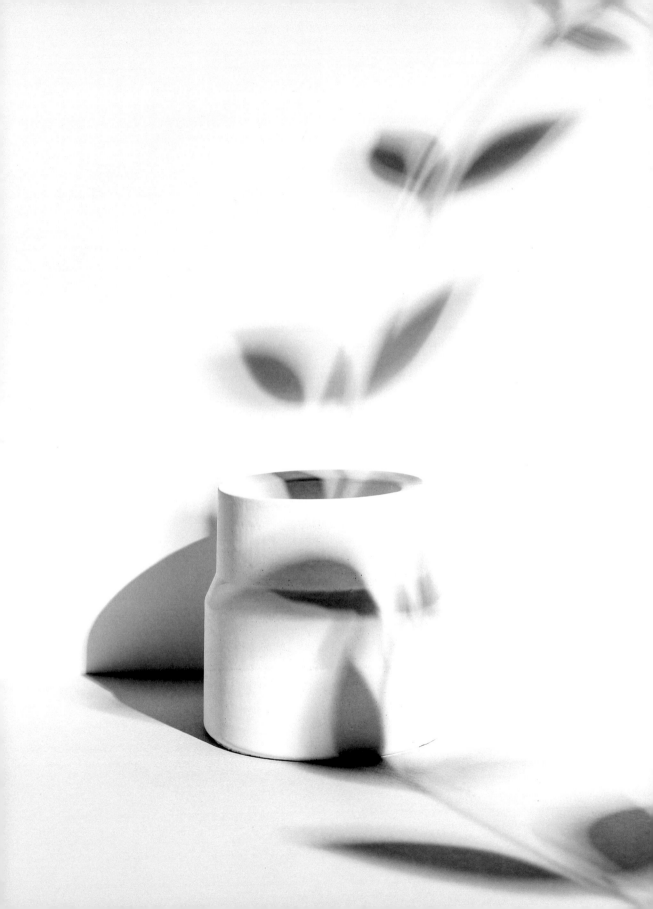

[4] When Queen Esther's maids and eunuchs came and told her about Mordecai, she was deeply distressed. She sent clothing to him to replace the burlap, but he refused it. [5] Then Esther sent for Hathach, one of the king's eunuchs who had been appointed as her attendant. She ordered him to go to Mordecai and find out what was troubling him and why he was in mourning. [6] So Hathach went out to Mordecai in the square in front of the palace gate. [7] Mordecai told him the whole story, including the exact amount of money Haman had promised to pay into the royal treasury for the destruction of the Jews. [8] Mordecai gave Hathach a copy of the decree issued in Susa that called for the death of all Jews. He asked Hathach to show it to Esther and explain the situation to her. He also asked Hathach to direct her to go to the king to beg for mercy and plead for her people. [9] So Hathach returned to

Esther with Mordecai's message. [10] Then Esther told Hathach to go back and relay this message to Mordecai: [11] "All the king's officials and even the people in the provinces know that anyone who appears before the king in his inner court without being invited is doomed to die unless the king holds out his gold scepter. And the king has not called for me to come to him for thirty days." [12] So Hathach gave Esther's message to Mordecai. [13] Mordecai sent this reply to Esther; "Don't think for a moment that because you're in the palace you will escape when all other Jews are killed. [14] If you keep quiet at a time like this, deliverance and relief for the Jews will arise from some other place, but you and your relatives will die. Who knows if perhaps you were made queen for just such a time as this?"

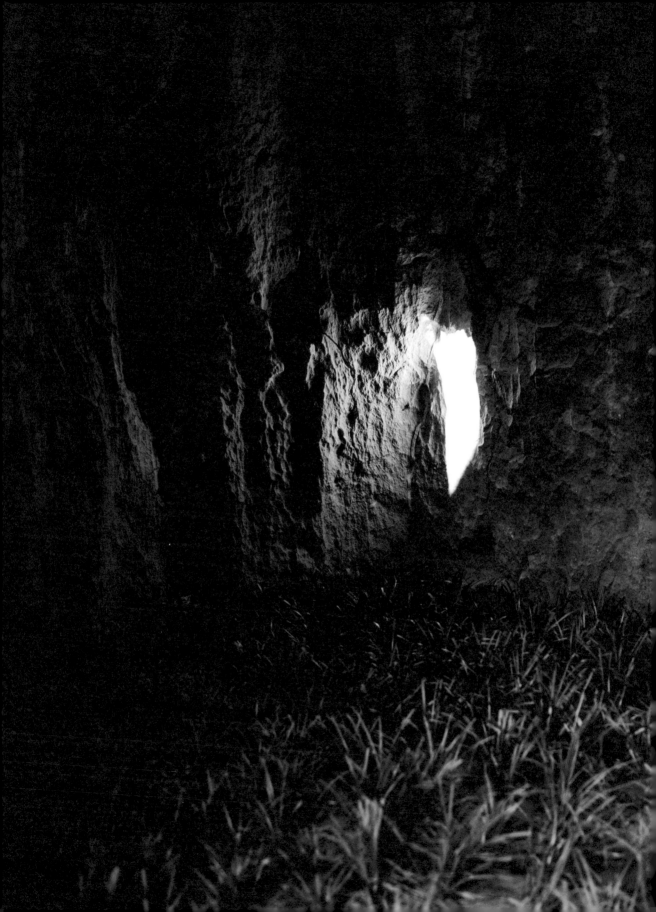

[15] Then Esther sent this reply to Mordecai: [16] "Go and gather together all the Jews of Susa and fast for me. Do not eat or drink for three days, night or day. My maids and I will do the same. And then, though it is against the law, I will go in to see the king. If I must die, I must die." [17] So Mordecai went away and did everything as Esther had ordered him.

5

ESTHER'S REQUEST TO THE KING

[1] On the third day of the fast, Esther put on her royal robes and entered the inner court of the palace, just across from the king's hall. The king was sitting on his royal throne, facing the entrance. [2] When he saw Queen Esther standing there in the inner court, he welcomed her and held out the gold scepter to her. So Esther approached and touched the end of the scepter. [3] Then the king asked her, "What do you want, Queen Esther? What is your request? I will give it to you, even if it is half the kingdom!" [4] And Esther replied, "If it please the king, let the king and Haman come today to a banquet I have prepared for the king." [5] The king turned to his attendants and said, "Tell Haman to come quickly to a banquet, as Esther has requested." So the king and Haman went to Esther's banquet.

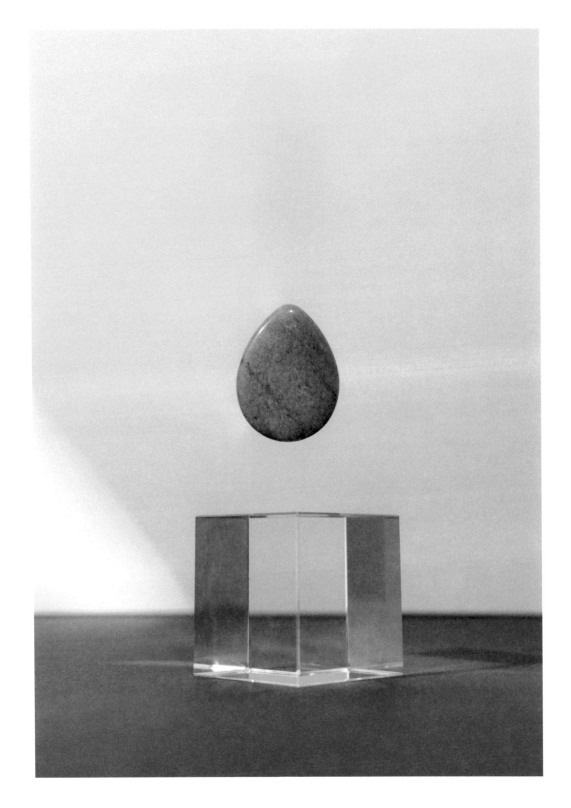

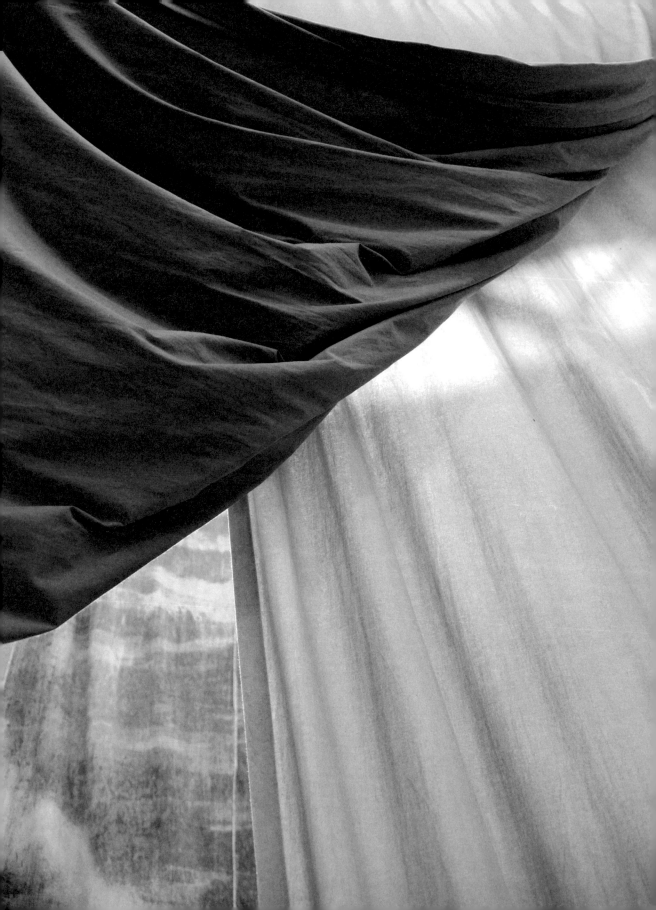

⁶ And while they were drinking wine, the king said to Esther, "Now tell me what you really want. What is your request? I will give it to you, even if it is half the kingdom!" ⁷ Esther replied, "This is my request and deepest wish. ⁸ If I have found favor with the king, and if it pleases the king to grant my request and do what I ask, please come with Haman tomorrow to the banquet I will prepare for you. Then I will explain what this is all about."

HAMAN'S PLAN TO KILL MORDECAI

⁹ Haman was a happy man as he left the banquet! But when he saw Mordecai sitting at the palace gate, not standing up or trembling nervously before him, Haman became furious. ¹⁰ However, he restrained himself and went on home. Then Haman gathered together his friends and Zeresh, his wife, ¹¹ and boasted to them about his great wealth and his many children. He bragged about the honors the king had given him and how he had been promoted over all the other nobles and officials. ¹² Then Haman added, "And that's not all! Queen Esther invited only me and the king himself to the banquet she prepared for us. And she has invited me to dine with her and the king again tomorrow!" ¹³ Then he added, "But this is all worth nothing as long as I see Mordecai the Jew just sitting there

at the palace gate." [11] So Haman's wife, Zeresh, and all his friends suggested, "Set up a sharpened pole that stands seventy-five feet tall, and in the morning ask the king to impale Mordecai on it. When this is done, you can go on your merry way to the banquet with the king." This pleased Haman, and he ordered the pole set up.

6

THE KING HONORS MORDECAI

[1] That night the king had trouble sleeping, so he ordered an attendant to bring the book of the history of his reign so it could be read to him. [2] In those records he discovered an account of how Mordecai had exposed the plot of Bigthana and Teresh, two of the eunuchs who guarded the door to the king's private quarters. They had plotted to assassinate King Xerxes. [3] "What reward or recognition did we ever give Mordecai for this?" the king asked. His attendants replied, "Nothing has been done for him." [4] "Who is that in the outer court?" the king inquired. As it happened, Haman had just arrived in the outer court of the palace to ask the king to impale Mordecai on the pole he had prepared. [5] So the attendants replied to the king, "Haman is out in the court."

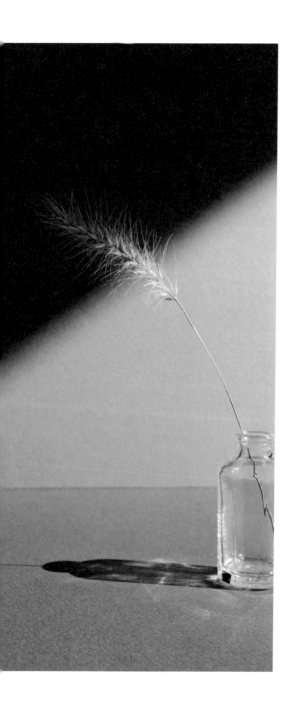

"Bring him in," the king ordered. [6] So Haman came in, and the king said, "What should I do to honor a man who truly pleases me?" Haman thought to himself, "Whom would the king wish to honor more than me?" [7] So he replied, "If the king wishes to honor someone, [8] he should bring out one of the king's own royal robes, as well as a horse that the king himself has ridden—one with a royal emblem on its head. [9] Let the robes and the horse be handed over to one of the king's most noble officials. And let him see that the man whom the king wishes to honor is dressed in the king's robes and led through the city square on

the king's horse. Have the official shout as they go, 'This is what the king does for someone he wishes to honor!'" [10] "Excellent!" the king said to Haman. "Quick! Take the robes and my horse, and do just as you have said for Mordecai the Jew, who sits at the gate of the palace. Leave out nothing you have suggested!" [11] So Haman took the robes and put them on Mordecai, placed him on the king's own horse, and led him through the city square, shouting, "This is what the king does for someone he wishes to honor!" [12] Afterward Mordecai returned to the palace gate, but Haman hurried home dejected and completely humiliated.

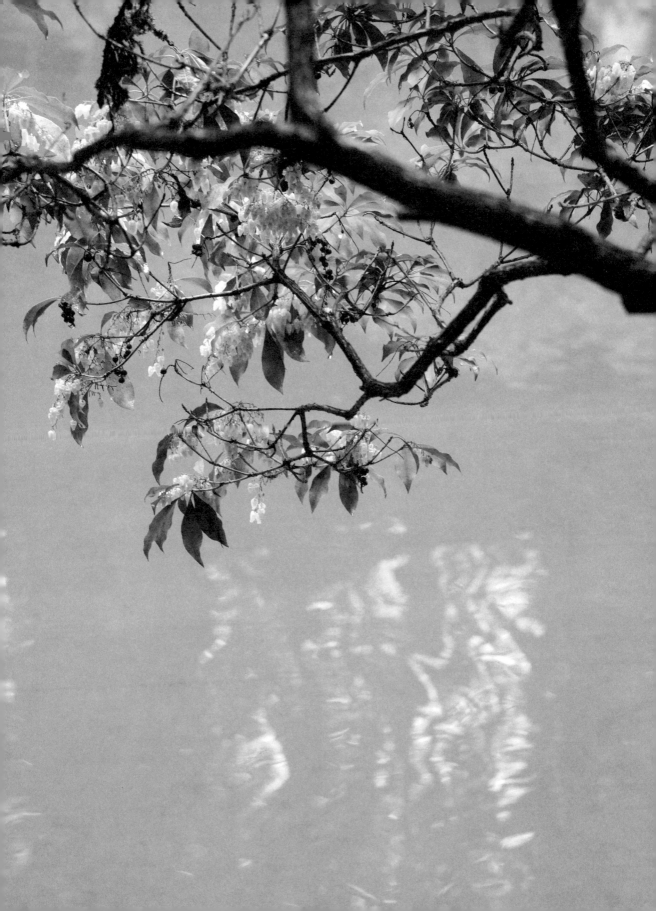

[13] When Haman told his wife, Zeresh, and all his friends what had happened, his wise advisers and his wife said, "Since Mordecai—this man who has humiliated you—is of Jewish birth, you will never succeed in your plans against him. It will be fatal to continue opposing him." [14] While they were still talking, the king's eunuchs arrived and quickly took Haman to the banquet Esther had prepared.

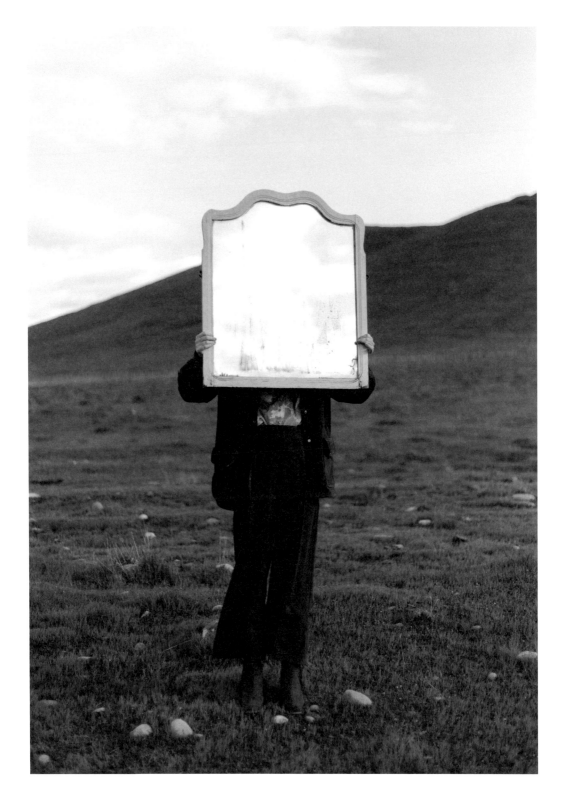

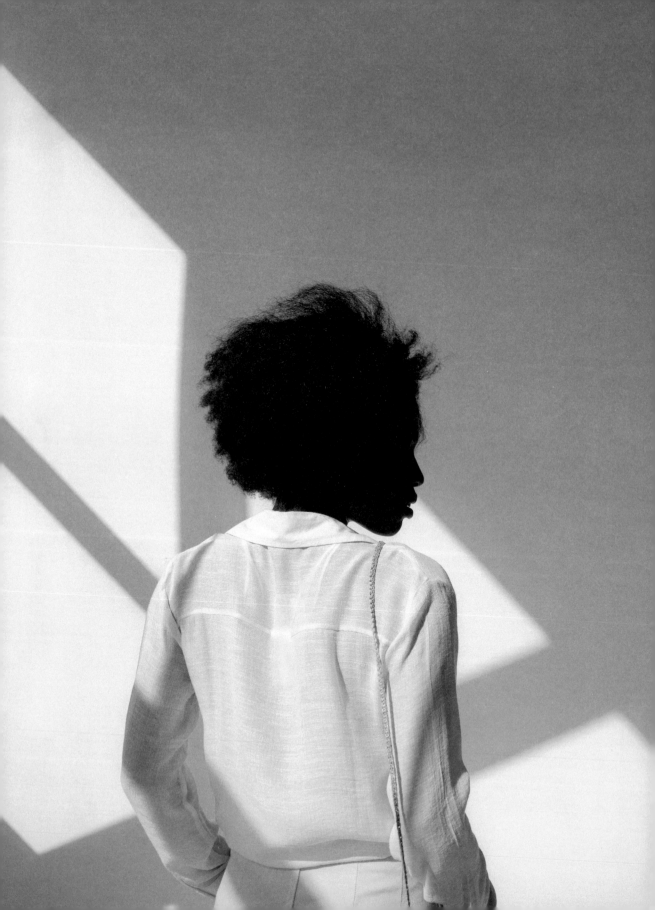

7

THE KING EXECUTES HAMAN

[1] So the king and Haman went to Queen Esther's banquet. [2] On this second occasion, while they were drinking wine, the king again said to Esther, "Tell me what you want, Queen Esther. What is your request? I will give it to you, even if it is half the kingdom!" [3] Queen Esther replied, "If I have found favor with the king, and if it pleases the king to grant my request, I ask that my life and the lives of my people will be spared. [4] For my people and I have been sold to those who would kill, slaughter, and annihilate us. If we had merely been sold as slaves, I could remain quiet, for that would be too trivial a matter to warrant disturbing the king."

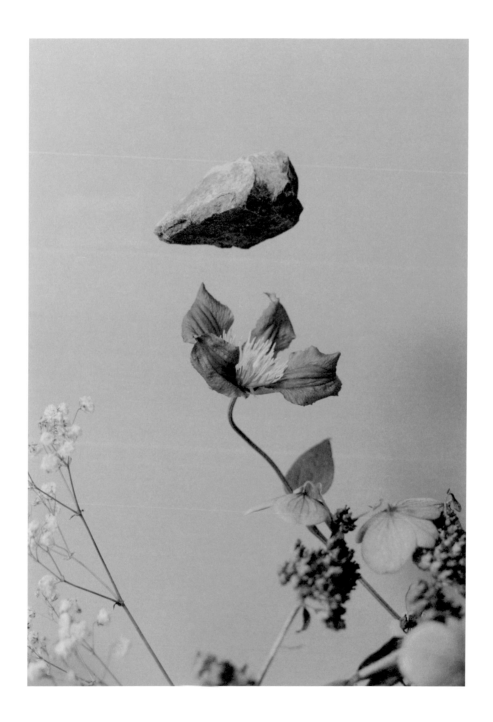

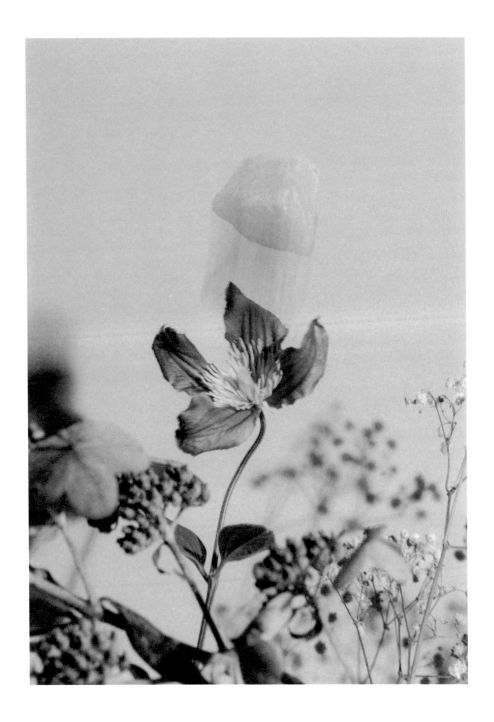

[5] "Who would do such a thing?" King Xerxes demanded. "Who would be so presumptuous as to touch you?" [6] Esther replied, "This wicked Haman is our adversary and our enemy." Haman grew pale with fright before the king and queen. [7] Then the king jumped to his feet in a rage and went out into the palace garden. Haman, however, stayed behind to plead for his life with Queen Esther, for he knew that the king intended to kill him. [8] In despair he fell on the couch where Queen Esther was reclining, just as the king was returning from the palace garden. The king exclaimed, "Will he even assault the queen right here in the palace, before my very eyes?" And as soon as the king spoke, his attendants covered Haman's face, signaling his doom.

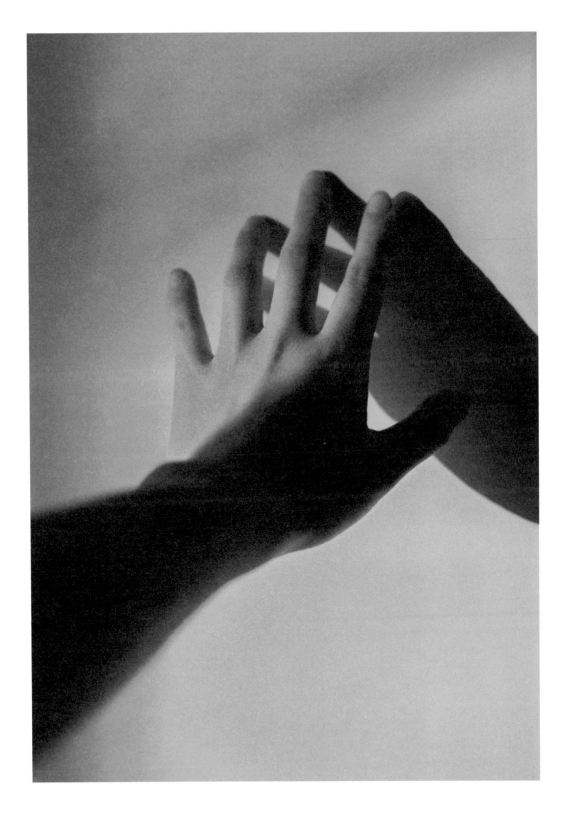

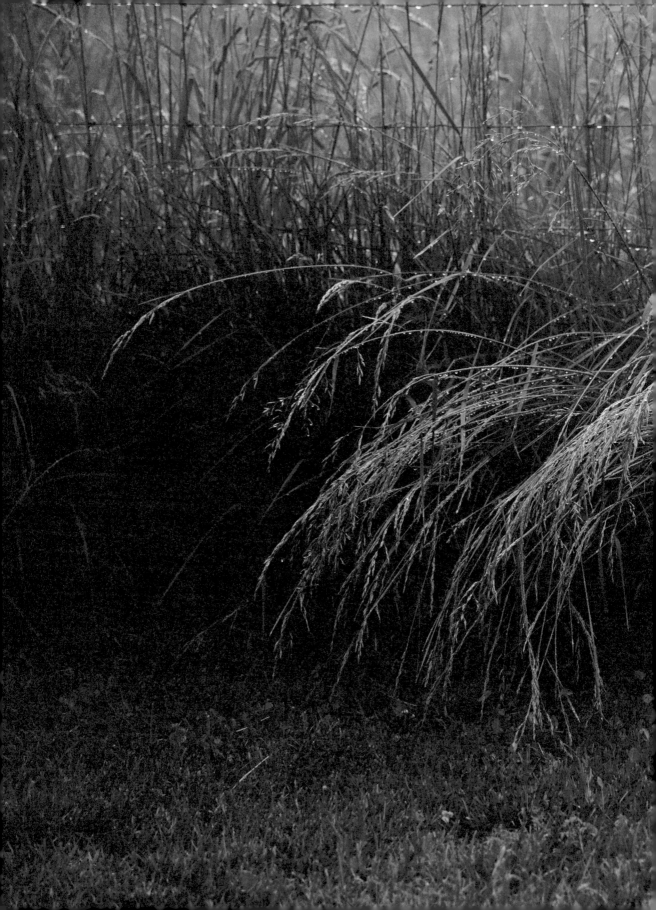

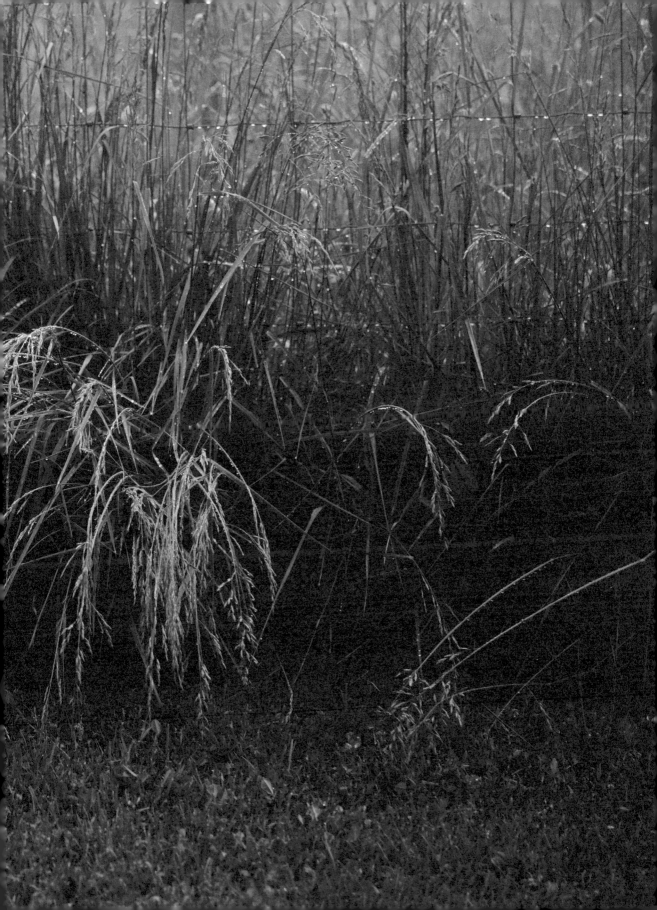

[9] Then Harbona, one of the king's eunuchs, said, "Haman has set up a sharpened pole that stands seventy-five feet tall in his own courtyard. He intended to use it to impale Mordecai, the man who saved the king from assassination." "Then impale Haman on it!" the king ordered. [10] So they impaled Haman on the pole he had set up for Mordecai, and the king's anger subsided.

8

A DECREE TO HELP THE JEWS

[1] On that same day King Xerxes gave the property of Haman, the enemy of the Jews, to Queen Esther. Then Mordecai was brought before the king, for Esther had told the king how they were related. [2] The king took off his signet ring—which he had taken back from Haman—and gave it to Mordecai. And Esther appointed Mordecai to be in charge of Haman's property. [3] Then Esther went

again before the king, falling down at his feet and begging him with tears to stop the evil plot devised by Haman the Agagite against the Jews. [4] Again the king held out the gold scepter to Esther. So she rose and stood before him. [5] Esther said, "If it please the king, and if I have found favor with him, and if he thinks it is right, and if I am pleasing to him, let there be a decree that reverses the orders of Haman son of Hammedatha the Agagite, who ordered that Jews throughout all the king's provinces should be destroyed.

⁶ For how can I endure to see my people and my family slaughtered and destroyed?" ⁷ Then King Xerxes said to Queen Esther and Mordecai the Jew, "I have given Esther the property of Haman, and he has been impaled on a pole because he tried to destroy the Jews. ⁸ Now go ahead and send a message to the Jews in the king's name, telling them whatever you want, and seal it with the king's signet ring. But remember that whatever has already been written in the king's name and sealed with his signet ring can never be revoked."

[9] So on June 25 the king's secretaries were summoned, and a decree was written exactly as Mordecai dictated. It was sent to the Jews and to the highest officers, the governors, and the nobles of all the 127 provinces stretching from India to Ethiopia. The decree was written in the scripts and languages of all the peoples of the empire, including that of the Jews. [10] The decree was written in the name of King Xerxes and sealed with the king's signet ring. Mordecai sent the dispatches by swift messengers, who rode fast horses especially bred for the king's service. [11] The king's decree gave the Jews in every city authority to unite to defend their lives. They were allowed to kill, slaughter, and annihilate anyone of any nationality or province who might attack them or their children and wives, and to take the property of their enemies. [12] The day chosen for this event throughout all the provinces of King Xerxes was March 7 of the next year. [13] A copy of this decree was to be issued as law in every province and proclaimed to all peoples, so that the Jews would be ready to take revenge on their enemies on the appointed day. [14] So urged on by the king's command, the messengers rode out swiftly on fast horses bred for the king's service. The same decree was also proclaimed in the fortress of Susa.

[15] Then Mordecai left the king's presence, wearing the royal robe of blue and white, the great crown of gold, and an outer cloak of fine linen and purple. And the people of Susa celebrated the new decree. [16] The Jews were filled with joy and gladness and were honored everywhere. [17] In every province and city, wherever the king's decree arrived, the Jews rejoiced and had a great celebration and declared a public festival and holiday. And many of the people of the land became Jews themselves, for they feared what the Jews might do to them.

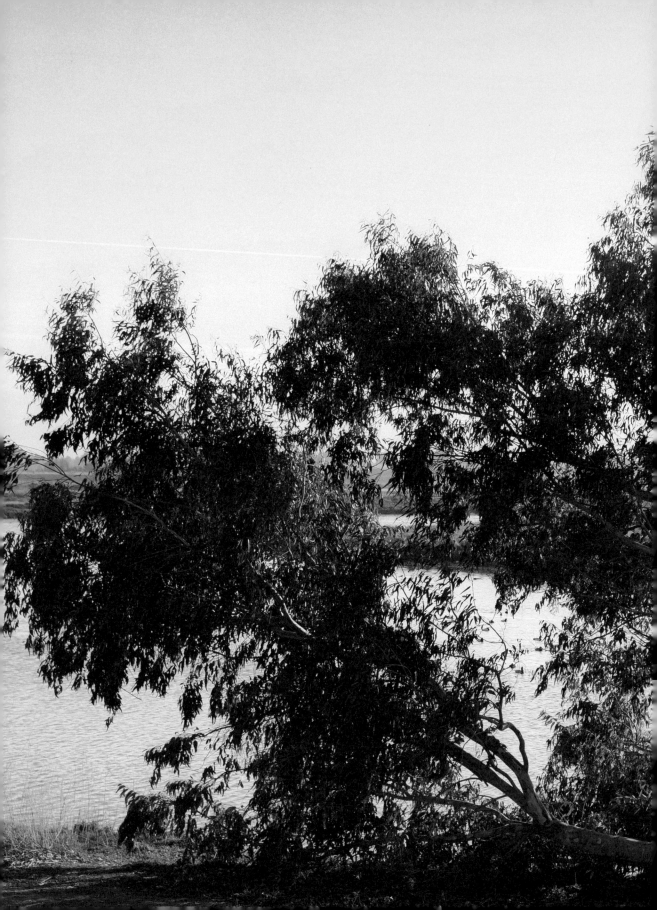

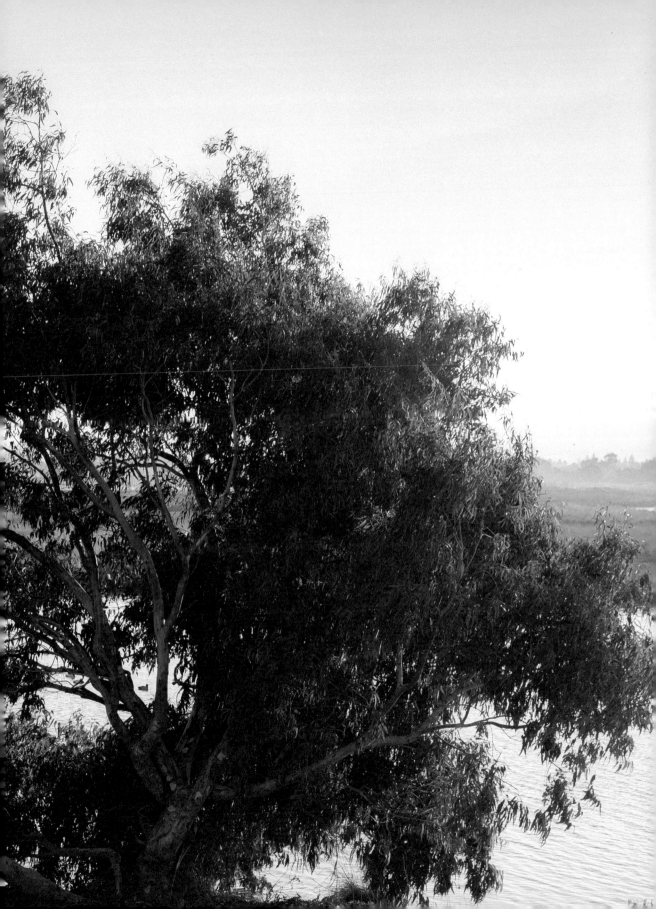

9

THE VICTORY OF THE JEWS

[1] So on March 7 the two decrees of the king were put into effect. On that day, the enemies of the Jews had hoped to overpower them, but quite the opposite happened. It was the Jews who overpowered their enemies. [2] The Jews gathered in their cities throughout all the king's provinces to attack anyone who tried to harm them. But no one could make a stand against them, for everyone was afraid of them. [3] And all the nobles of the provinces, the highest officers, the governors, and the royal officials helped the Jews for fear of Mordecai. [4] For Mordecai had been promoted in the king's palace, and his fame spread throughout all the provinces as he became more and more powerful. [5] So the Jews went ahead on the appointed day and struck down their enemies with the sword. They killed and annihilated their enemies and did as they pleased with those who hated them. [6] In the fortress of Susa itself, the Jews killed 500 men. [7] They also killed Parshandatha, Dalphon, Aspatha, [8] Poratha, Adalia, Aridatha, [9] Parmashta, Arisai, Aridai, and Vaizatha— [10] the ten sons of Haman son of Hammedatha, the enemy of the Jews. But they did not take any plunder. [11] That very day, when the king was informed of the number of people killed in the fortress of Susa, [12] he called for Queen Esther. He said, "The Jews have killed 500 men in the fortress of Susa alone, as well as Haman's ten sons. If they have done that here, what has happened in the rest of the provinces? But now, what more do you want? It will be granted to you; tell me and I will do it."

[13] Esther responded, "If it please the king, give the Jews in Susa permission to do again tomorrow as they have done today, and let the bodies of Haman's ten sons be impaled on a pole." [14] So the king agreed, and the decree was announced in Susa. And they impaled the bodies of Haman's ten sons. [15] Then the Jews at Susa gathered together on March 8 and killed 300 more men, and again they took no plunder. [16] Meanwhile, the other Jews throughout the king's provinces had gathered together to defend their lives. They gained relief from all their enemies, killing 75,000 of those who hated them. But they did not take any plunder. [17] This was done throughout the provinces on March 7, and on March 8 they rested, celebrating their victory

with a day of feasting and gladness. [18] (The Jews at Susa killed their enemies on March 7 and again on March 8, then rested on March 9, making that their day of feasting and gladness.) [19] So to this day, rural Jews living in remote villages celebrate an annual festival and holiday on the appointed day in late winter, when they rejoice and send gifts of food to each other.

THE FESTIVAL OF PURIM

[20] Mordecai recorded these events and sent letters to the Jews near and far, throughout all the provinces of King Xerxes, [21] calling on them to celebrate an annual festival on these two days. [22] He told them to celebrate these days with feasting and gladness and by giving gifts of food to each other and presents to the poor. This would commemorate a time when the Jews gained relief from their enemies, when their sorrow was turned into gladness and their mourning into joy. [23] So the Jews accepted Mordecai's proposal and adopted this annual custom. [24] Haman son of Hammedatha the Agagite, the enemy of the Jews, had plotted to crush and destroy them on the date determined by casting lots (the lots were called *purim*). [25] But when Esther came before the king, he issued a decree causing Haman's evil plot to backfire, and Haman and his sons were impaled on a sharpened pole. [26] That is why this celebration is called Purim, because it is the ancient word for casting lots. So

because of Mordecai's letter and because of what they had experienced, [27] the Jews throughout the realm agreed to inaugurate this tradition and to pass it on to their descendants and to all who became Jews. They declared they would never fail to celebrate these two prescribed days at the appointed time each year. [28] These days would be remembered and kept from generation to generation and celebrated by every family throughout the provinces and cities of the empire. This Festival of Purim would never cease to be celebrated among the Jews, nor would the memory of what happened ever die out among their descendants. [29] Then Queen Esther, the daughter of Abihail, along with Mordecai the Jew, wrote another letter putting the queen's full authority behind Mordecai's letter to establish the Festival of Purim. [30] Letters wishing peace and security were sent to the Jews throughout the 127 provinces of the empire of Xerxes. [31] These letters established the Festival of Purim—an annual celebration of these days at the appointed time, decreed by both Mordecai the Jew and Queen Esther. (The people decided to observe this festival, just as they had decided for themselves and their descendants to establish the times of fasting and mourning.) [32] So the command of Esther confirmed the practices of Purim, and it was all written down in the records.

10

THE GREATNESS OF XERXES AND MORDECAI

[1] King Xerxes imposed a tribute throughout his empire, even to the distant coastlands. [2] His great achievements and the full account of the greatness of Mordecai, whom the king had promoted, are recorded in *The Book of the History of the Kings of Media and Persia*. [3] Mordecai the Jew became the prime minister, with authority next to that of King Xerxes himself. He was very great among the Jews, who held him in high esteem, because he continued to work for the good of his people and to speak up for the welfare of all their descendants.

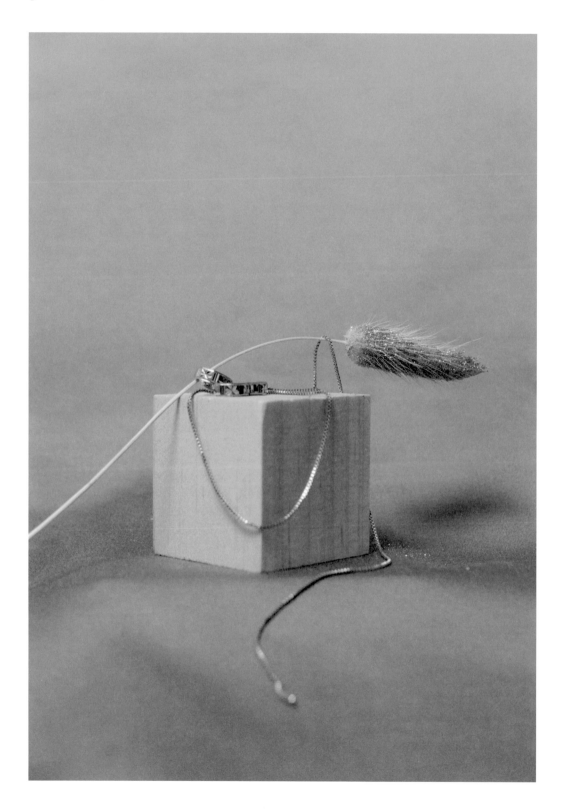

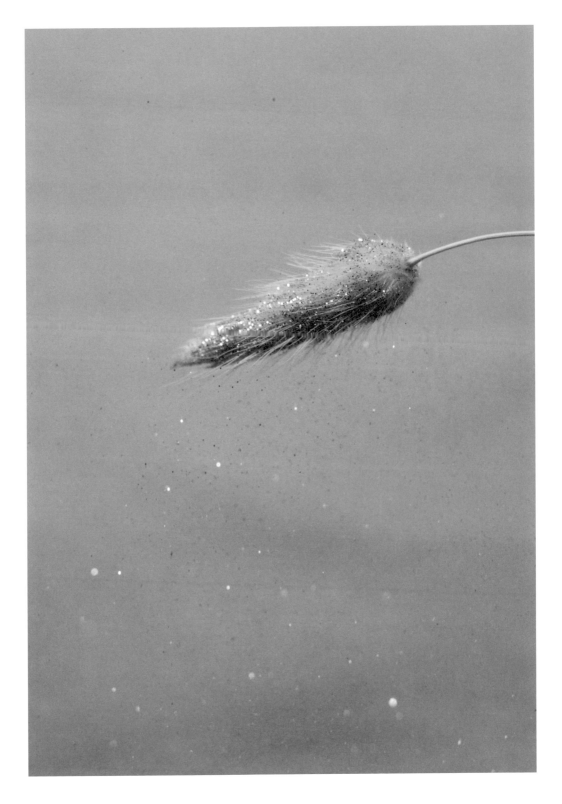

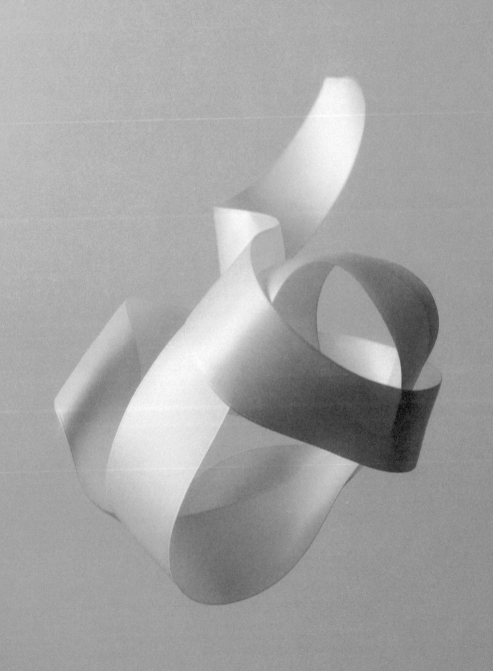

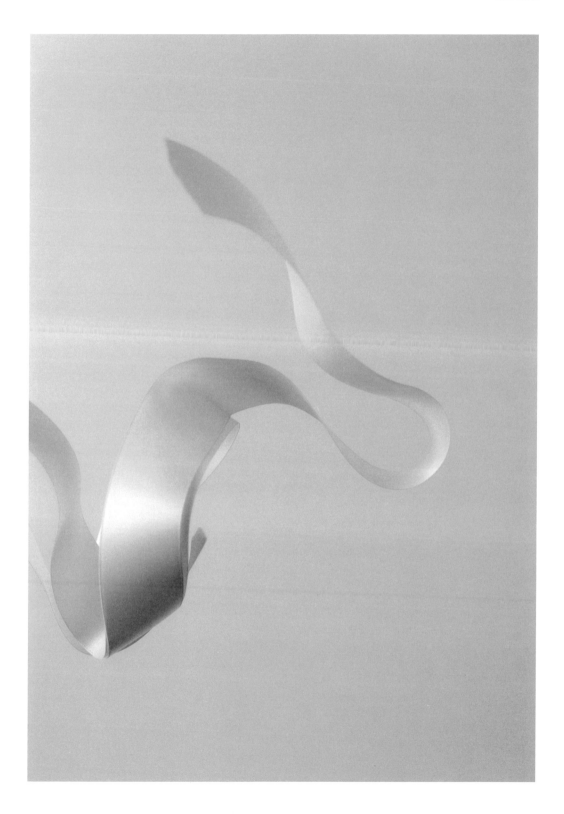

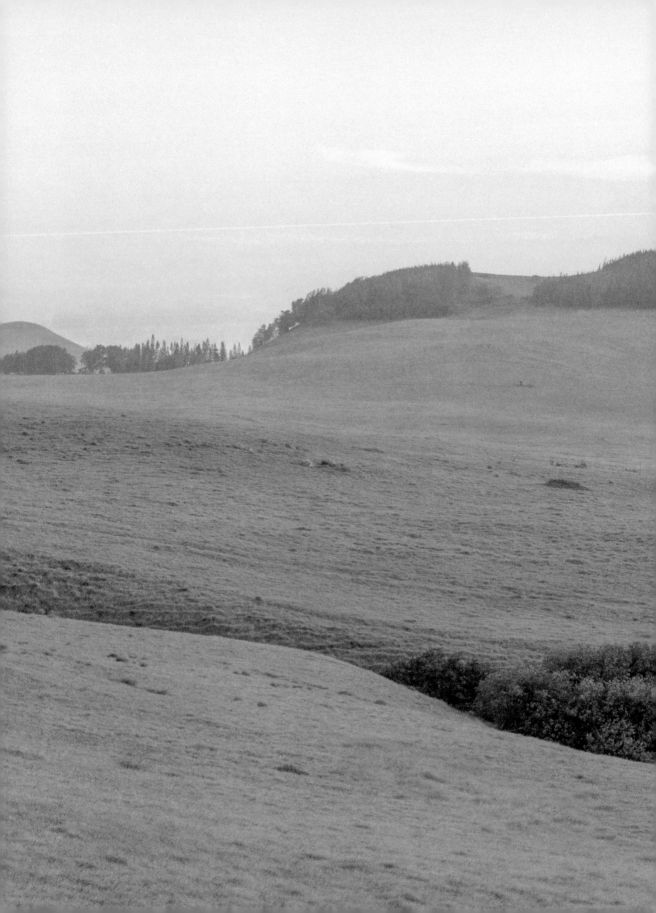

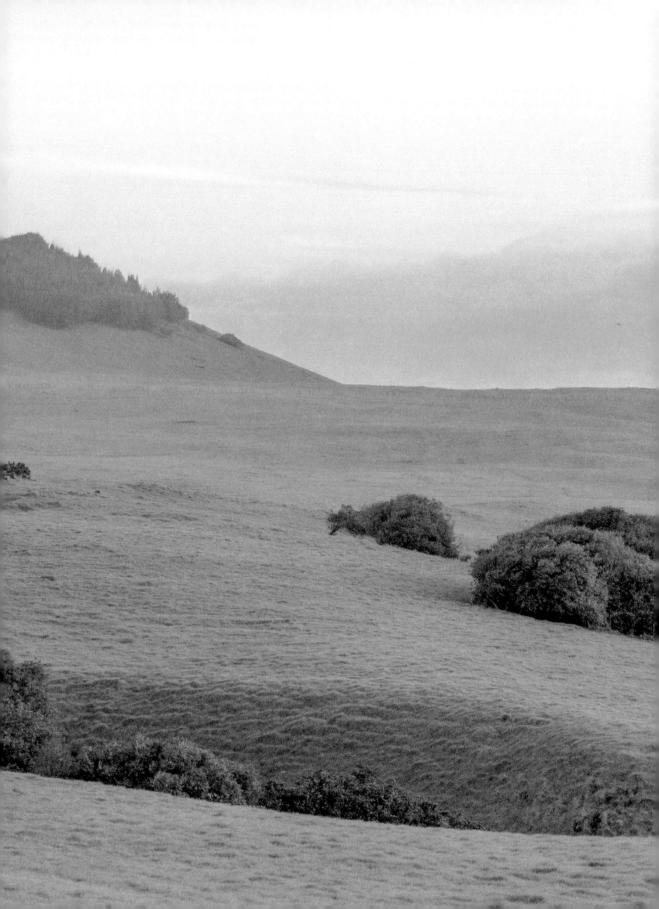

ALABASTER

TYLER ZAK
Product Manager, Art Director

MATTHEW RAVENELLE
Layout Designer

SAMUEL HAN
Studio Manager, Cover Image

MARK YEONGJUN SEO
Studio Stylist

ALEXIS SOOMIN LEE
Studio Assistant

BRYAN YE-CHUNG
Co-Founder, Creative Director

BRIAN CHUNG
Co-Founder, Managing Director

WILLA JIN
Operations Director

EMALY HUNTER
Customer Experience Specialist

DARIN MCKENNA
Content Editor

JOSEPHINE LAW
Original Designer

ALABASTER

PHOTOGRAPHERS

Andriana Kovalchuk
Chester Nathanael Wright
Echo Yun Chen
Haven Kim
Heidi Parra
Ian Teraoka
Joel Rojas
Jonathan Knepper
Lois Lee
Mike Sunu

Nathan van de Graaf
Salomé Watel
Samuel Han
Stephen Rheeder

MODELS

Alexis Soomin Lee
Lauren Hurr
Mark Yeongjun Seo

CONTINUE THE CONVERSATION

www.alabasterco.com